TRADEMARKS OF
20'S AND 30'S

TRADEMARKS OF THE 20'S AND 30'S

BY
ERIC BAKER & TYLER BLIK

•

INTRODUCTION BY PRIMO ANGELI

TEXT BY JOEL LIPMAN

CHRONICLE BOOKS
SAN FRANCISCO

Printed in Hong Kong.
Cover by Michael Doret

Library of Congress Cataloging in Publication Data

Baker, Eric, 1949-
 Trademarks of the 20's and 30's.

 1. Trade-marks—United States—History—20th
century—Themes, motives. 2. Art deco. 3. Commercial
art—United States—Themes, motives. I. Blik, Tyler.
II. Title. III. Title; Trademarks of the twenties
and thirties.
NC998.5.A1B35 1985 741.6 85-11355
ISBN 0-87701-360-8 (pbk.)

10 9 8 7 6

Chronicle Books
275 Fifth Street
San Francisco, CA 94103

Distributed in Canada by Raincoast Books,
8680 Cambie Street, Vancouver, B.C. V6P 6M9

A project such as this, is in truth, the effort of many people. Without the help, inspiration and encouragement of these people this book would have never been produced.

We would like to thank the following people for their invaluable assistance and friendship: Tim and Sue Reamer, Alba Gracci, John Watson, Primo Angeli, Joel Lipman, Michael Doret, Melinda Currier, Vickey Hanson, The staff of the Science and Industry Department at the San Diego Public Library, Don and Debra McQuiston, James Reavis and David Barich.

Eric Baker & Tyler Blik

LADIES & GENTLEMEN

TRANSPORTATION

COWBOYS & INDIANS

FACES & FIGURES

INTRODUCTION

The discoveries of Eric Baker and Tyler Blik, represented in this vivid documentation of American trademarks and logotypes, dramatically capture the social speed at which a graphic-minded, industrious United States was traveling in the 1920s and 1930s. This rich trove of American commercial art could legitimately be subtitled "Words and Music of an Industrial America," for the captions to these visual "inventions" exhibited as much humor and color as the drawings themselves. The marks were the products of professional artists and designers, as well as those early design primitives, small businessmen.

Baker and Blik have not only selected the award winners of the period, as with many trademark collections, but also examples of the naive and humorous, which incidentally were the most expressive. Their source, you see, was that fabulous, unbiased chronologer of all things possible, the United States Patent Office.

Entertaining in their own right, these graphic expressions can also be read as cultural barometers. Each one is a short story, an ideogram of the decade, an episode that contributes to the whole era pictured in this collection. Its pages contain clear visual evidence of the transition from a rural-agricultural economy to an urban-industrial one. The innovative design forms here echo the technological impact of the streamlined era—visual fantasies

of motion and, in response to the Great Depression, of escape.

Were our senses and intuitive abilities stronger in the 1920s and 1930s? How did artists address the target concern of today's designers, the demographics of the consumer? In order to reach their customers, it seems to me, they often consulted that original personal computer located somewhere behind the eyes. Contemporary expression, on the other hand, is much more systematic and regulated, more often objective than subjective, and less exciting in certain respects.

The fact that many of these period trademarks were illustrated without the benefit of sophisticated research is far from a liability. Rich, unique personalities surface in them to such an extent and with such great style that, by comparison, most contemporary trademark collections seem shoved into one vast, impersonal grid system of sameness. Today we are faced with a bland diet of predictably nice forms, with few surprises or warmth. This collection is a captivating black-and-white silhouette of the more dynamic 1920s and 1930s: deluxe, naive, and rare.

Primo Angeli
San Francisco, 1985

Post-World War I America had finally established an identity for itself. The initial roar and glamor of the twenties eased into a new, more sophisticated style. These were the Roosevelt Years. The Gershwin Years. The Golden Age of Hollywood.

Never before had Americans seen themselves with such singular vision. High fashion for men was a top hat, tails, and spats; for women, it was evening gowns, with a lot of shoulder and just a glimpse of her Charna Leas. Hollywood churned out the look and the advertisers ate it up. Fred and Ginger. Clark and Myrna. The Wilshire Man and Lady Jordan.

The trademarks in this section closely mirror the prevailing art style of the period, the crisp, simplistic, black-and-white silhouettes of Art Deco.

The Art Deco influence touched more than just the silver screen in the twenties and thirties. Its distinct impression was left on everything, from fine art and architecture to fashion design. Advertisers quickly found that representing their product with an Art Deco trademark gave it a modern, widely accepted image.

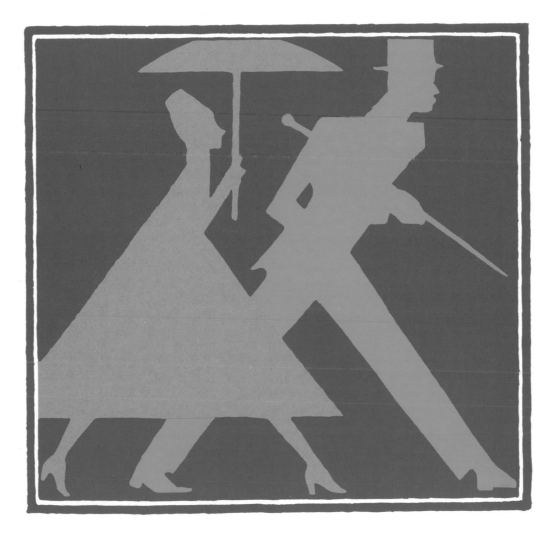

1925, Lotus Limited, Stafford, England. Boots and Shoes Made of
Leather.

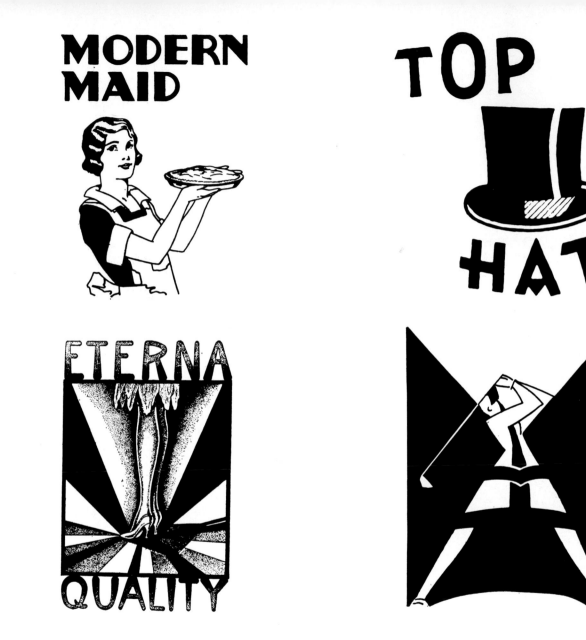

MODERN MAID

TOP HAT

ETERNA QUALITY

1928, **Modern Maid Foods, Inc.,** Los Angeles, California. Pie-Crust Flour and Waffle Flour.

1928, **Finlay, Holt & Co. Ltd.,** New York, New York. Hosiery.

1935, **Spatz Brothers,** New York, New York. Hats.

1928, **The Sportswoman, Inc.,** New York, New York. Women's Sports Garments—Namely, Dresses, Suits, Ensembles, and Sweaters.

1936, The Weisbaum Bros., Brower Co., Cincinnati, Ohio. Men's Neckties and Mufflers.

1929, The Walnut Creek Milling Co., Great Bend, Kansas. Wheat Flour.

1920, St. Louis Food Products Co., St. Louis, Missouri. Prepared Compressed Soup.

1936, Oscar R. Loewenthal, Seattle, Washington. Duplicating Laundry List Books.

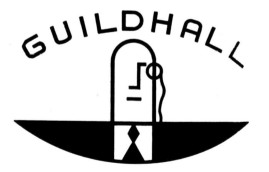

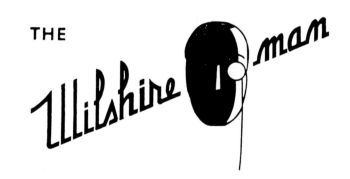

1938, **Rival Manufacturing Co.,** Kansas City, Missouri. Base Metal Steak Platters.

1936, **The Guild Shirt Co.,** Hazeltown, Pennsylvania. Outer Shirts and Pajamas of Textile Fabrics.

1938, **E. H. Spiegl,** Salinas, California. Fresh Vegetables.

1937, **Bullock's, Inc.,** Los Angeles, California. Hand Soap and Shaving Cream.

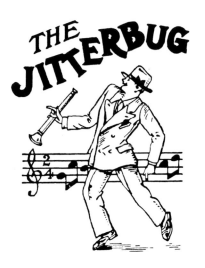

1938, The La Salle Hat Co., Philadelphia, Pennsylvania. Men's and Boys' Hats and Caps and Ladies' Hats.

1937, Marine Products Co., San Diego, California. Canned Tuna.

1925, Edward S. Goldhill, New York, New York. Doughnuts.

1934, Standard Products Co., Chicago, Illinois. Whiskey.

CharnaLea

WORLD'S FAIR

1937, Crafters, Inc., Lansdowne, Pennsylvania. Candy Novelties for Decorating Cakes, Ice Cream, Candies, and Desserts.

1937, Edgar C. Hyman Co., New York, New York. Ladies' Scarfs.

1938, Undergarment Manufacturing Co., Fort Wayne, Indiana. Ladies', Misses', and Children's Undergarments.

1934, J. P. Lasto Co., New York, New York. Alcoholic Bitters and Cocktails.

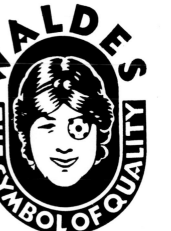

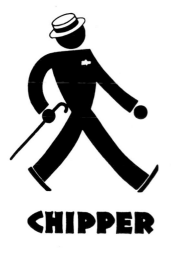

1938, Coopers, Inc., Kenosha, Wisconsin. Men's Undergarments.

1938, Westerman-Rosenberg Inc., New York, New York. Ladies' Handbags.

1935, Waldes Koh-I-Noor, Inc., Long Island City, New York. Slide Fasteners.

1936, Sprague Warner & Co., Chicago, Illinois. Coffee.

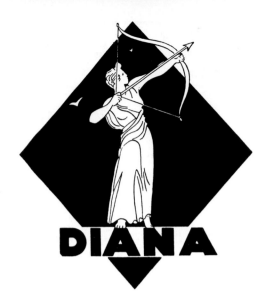

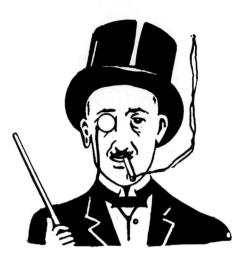

1934, S. Holst-Knudson, Los Angeles, California. Cheese.

1935, The American Tobacco Co., New York, New York. Cigarettes.

1927, Slick-O Mfg. Co., Los Angeles, California. Hairdressing.

1931, L. McGlothlen, Salt Lake City, Utah. Preparation for Holding Permanent Waves in Place.

1920, Samuel H. Robinson, Kansas City, Missouri. Optical Cases or Conveyors in Which Are Carried Eyeglasses, Spectacles, or Goggles.

1928, M & M Knitting Mills, Inc., Philadelphia, Pennsylvania. Bathing Suits.

1932, Helen G. Flaten, Los Angeles and Huntington Park, California. Hairdressing Preparations and Brilliantine.

1924, Kimball Brothers & Co. Inc., Enosberg Falls, Vermont. Hairdressing and Combing Preparation.

The Modern Witch

ABERLE

1927, Ipswich Mills, Boston, Massachusetts. Women's Knitted and Woven Underwear.

1935, H. C. Aberle Co., Philadelphia, Pennsylvania. Hosiery.

1930, Porcelain Tile Co., Chicago, Illinois. Wall and Floor Tiles

1928, Surprise Brand Products, Chicago, Illinois. Liquid and Semisolid Polish for Silverware, Gold, Diamonds, Platinum, and the Like.

1920, Taylor Bros., Camden, New Jersey. Automobile Accessories—Namely, Sparkplugs.

1934, Glorasheen Products Co., Los Angeles, California. Hair Coloring Preparation.

1938, The Virgin Islands Cooperative, Inc., St. Thomas, Virgin Islands. Foodstuffs—Namely Fruits and Vegetables.

1925, The Lucky Tiger Remedy Co., Kansas City, Missouri. Face Lotion Remedy Intended for After Shaving and Healing Facial Eruptions, Pimples, and Other Facial Disorders.

1938, Garner-Tarkenton, Wilson, North Carolina. Nonalcoholic Soda Fountain Beverage.

1925, Lang Knitting Mills, Inc., New York, New York. Knitted Underwear for Men, Women, and Children and Hosiery and Dresses for Misses, Ladies, and Juniors.

1925, L. Michaels, Inc., Buffalo, New York. Men's, Women's, and Children's Hosiery.

1938, Jordan Marsh Co., Boston, Massachusetts. Women's Shoes of Leather, Fabric, and Combinations of These Materials.

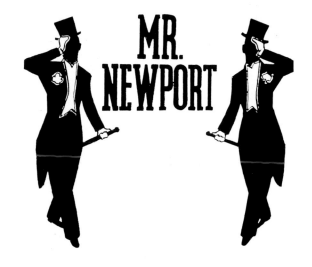

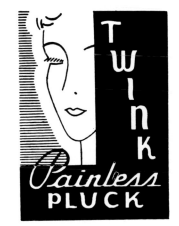

1938, The American Mills Co., West Haven, Connecticut. Elastic Webbing.

1936, Art-Mor Togs, Inc., New York, New York. Bathing Suits and Articles of Beachwear.

1938, Mr. Newport, Inc., Chicago, Illinois. Nonalcoholic Malted Beverages.

1937, Servad Laboratories, New York, New York. Chemical Preparation for the Aid of Eyebrow Tweezing.

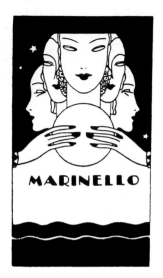

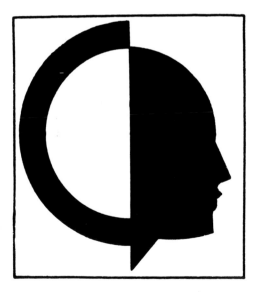

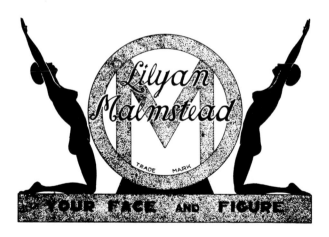

1932, Société Anonyme, Puteaux, France. Toilet Soaps, Soaps for the Treatment of Textiles.

1937, Cyclax Ltd., London England. For Preparations for Beautifying or Preserving the Natural Beauty of the Skin.

1931, Marinello Co., New York, New York. Tissue Cream.

1932, Lilyan Malmstead, Worcester, Massachusetts. Corsets, Girdles, Brassiéres, and Underwear for Girls and Women.

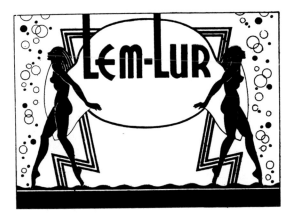

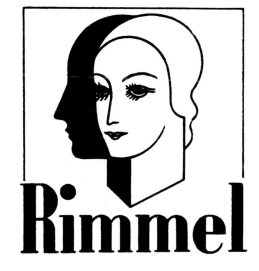

1931, Caled Products Co. Inc., Cottage City, Maryland. For Detergents—Namely, Liquid Cleanser Preparation.

1925, Oriental Silk Printing Co., Haledon, New Jersey and New York, New York. Textile Fabrics—Namely, Silk, Artificial Silk, Wool, and Cotton and Combinations Thereof.

1935, Lem-Lur Bottling Co., San Francisco, California. Nonalcoholic, Maltless Fruit Juice Compound for Beverage Purposes.

1932, Rimmel, Inc., West Orange, New Jersey. Astringents, Astringent Cerates, Bleach Creams and Beauty Creams.

1931, Straus, Royer & Strauss, Inc., Baltimore, Maryland. Women's and Children's Dresses, Shirts, Shorts, Blouses, Gym Bloomers, and Skirts.

1920, Herbert B. Lederman, New York, New York. Veils.

1935, The Lanier Co. Inc., New York, New York. For Eyebrow and Eyelash Grower, Eyebrow Pencils, Chemical Preparations Suitable for the Darkening of Eyelashes and Eyebrows.

1928, Smithson, New York, New York. Men's and Boys' Suits. Topcoats, and Overcoats.

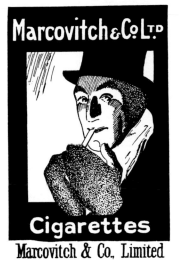

1938, Hospital Specialty Co., Whitewater, Wisconsin. Medicators.

1931, Wilson Brothers, Chicago, Illinois. Dress and Negligee Shirts, Pajamas, Men's Underwear, Hosiery, and Neckties.

1924, Marcovitch & Co., Ltd., London, England. Cigarettes.

1929, Powder Puff Shop, Minneapolis, Minnesota. Liquid Toilet Creams, Face Powders, Liquid Skin Coloring, and Liquid Powder Astringent.

ANIMALS

Since the beginning of time, man has shared this earth with creatures wild and free. Our fascination with them has ranged from a concern for survival to a wide-eyed sense of respect. We took some creatures as friends, some as food, and on a few beasts we bestowed a mythic godliness.

These trademarks harken back to the early warriors who decorated their shields with an animal's likeness in the hope that they could equal the strength of their chosen images. They carried into battle the agility of the leopard, the cunning of the fox, or the sting of the scorpion.

But times change. Designers altered the tune slightly, but kept the premise intact. In the twenties and thirties, animals were anthropomorphized with qualities that made them likable and friendly. Here among the Heron we find Nordic Fish, Tweety Birds with "something to sing about," Flip-The-Frog and his pal Phil-Up, even an alligator sporting a nifty travel bag.

Some say that American hucksters of the era could have sold manure to a cow—if it was packaged right. Genuine Peruvian Guano, pictured with a proud gull, is as close as you'll come to proving that point.

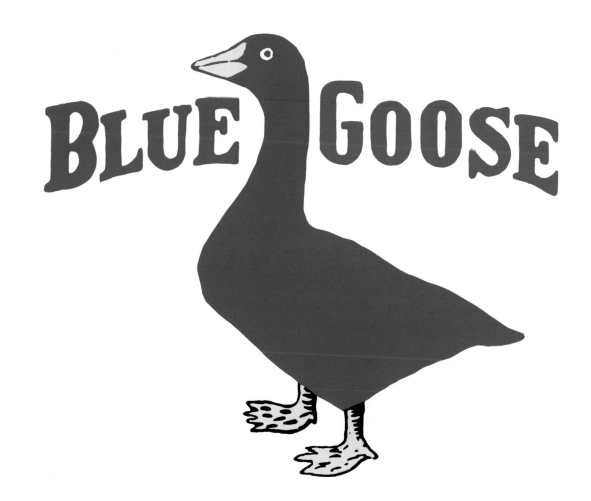

1924, Standard Textile Company, Memphis, Tennessee. Men's Work Shirts.

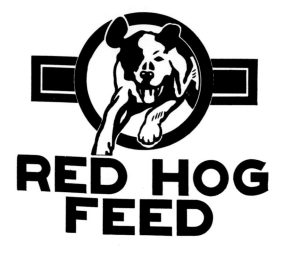

1925, M. Halff & Bro., San Antonio, Texas. Bleached Woven Cotton Cloth Commonly Called Bleached Domestics.

1925, Sun Soap Products Inc., Staten Island, New York, New York. Soap Powders.

1925, Empire Milling Co., Minneapolis, Minnesota. Hog Feed.

1925, Moorman Mfg. Co., Quincy, Illinois. Mineral Feed for Poultry.

1934, Hermann Sanders, St. Louis, Missouri. Lactic Preparation for Use as a General Bodybuilding Tonic.

1922, Washburn-Crosby Co., Minneapolis, Minnesota. Semolina and Durum Wheat Flour.

1935, National Coast Products Corp., Swedesboro, New Jersey. Canned Dog and Cat Food.

1925, Scott & Bowne, Bloomfield, New Jersey. Cod Liver Oil for Chickens.

1938, Julius Schmid, Inc., New York, New York. Prophylactic Rubber and Membraneous Articles for the Prevention of Contagious Diseases.

1925, Shuster Gormly Co., Jeanette, Pennsylvania. Canned Goods.

1934, Goebel Brewing Co., Detroit, Michigan. Beer.

1937, Socony-Vacuum Oil Co. Inc., New York, New York. Lubricating Oils and Petroleum Engine Fuels.

1925, Belle City Manufacturing Co., Racine and Racine Junction, Wisconsin. Thrashing Machinery, Tractors, Silo Fillers, and Feed Cutters.

1938, Pepperell Manufacturing Co., Boston, Massachusetts. Textile Fabrics in the Piece of All Types and Styles, Made of Cotton, Silk, Rayon, Artificial Silk.

1937, Melkon M. Samoorian, Somerville, Massachusetts. Cigarettes.

1925, Suffolk Brewing Co., Boston, Massachusetts. Cereal Malt Beverage.

1935, Fidalgo Island Packing Co., Seattle, Washington. Canned Salmon.

1932, Baumheier Chemical Co. Inc., New York, New York. Water Proofing Agent for Textile Fabrics.

1931, Atlantic Coast Fisheries Corp. of New York, New York, New York. Fish Steaks, Frozen Fish Fillets.

1938, Liberty Mills, Nashville, Tennessee. Wheat Flour.

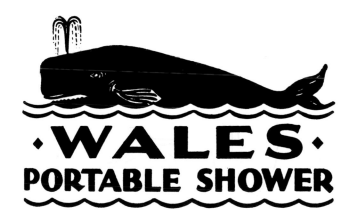

1925, Chemisch-Pharmazett, Chemisch-Pharmazeitische Fabrik, Berlin, Germany. Perfumery and Cosmetics—Namely, Hair Tonic and Hairwash.

1935, B. Heller & Co., Chicago, Illinois. Concentrated Liquid Laundry Blue.

1920, Aberdeen Packing Co., Aberdeen, Washington. Canned Salmon.

1932, Belmet Products, Inc., Brooklyn, New York. Portable Shoulder Shower.

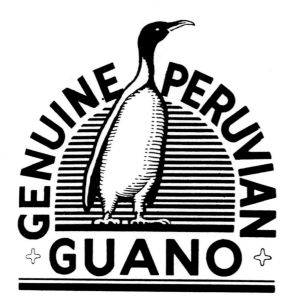

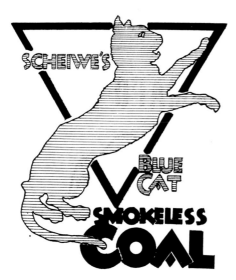

1925, Nitrate Agencies Co., New York, New York. Fertilizer.

1921, Lawson Brothers, Baltimore, Maryland. Men's and Boy's Coats, Vests, and Pants.

1927, Scheiwe Coal & Ice Co., Detroit, Michigan. Coal.

1930, Harry C. Eisenhut, Richmond Hill, New York. Bird Food.

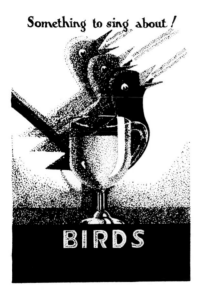

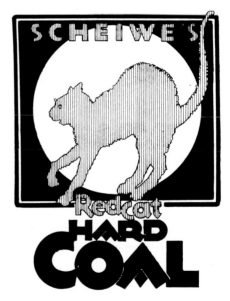

1936, Braided Fabric Co., Providence, Rhode Island. Knitting Bags, Bathing Bags, Tourist Bottle Kits, Hand Bags, and Shopping Bags.

1931, Alfred Bird and Sons, Limited, Birmingham, England. Custard Powder.

1924, Allwood Lime Co., Manitowoc, Wisconsin. Hydrated Lime.

1927, Scheiwe Coal & Ice Co., Detroit, Michigan. Coal.

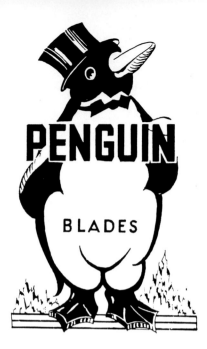

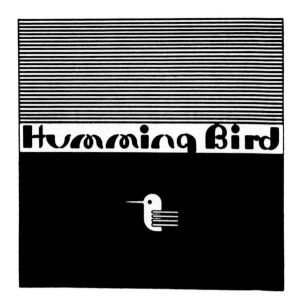

1938, Rider Safety Razor Co., New York, New York. Razor Blades and Pocket Knives for Personal Use.

1936, United States Rubber Products, Inc., New York, New York. Rubber Bathing and Beach Shoes, Rubber Bathing Caps, Rubber Girdles, and Rubber Bathing Suits.

1938, Davenport Hosiery Mills. Inc., Chattanooga, Tennessee. Hosiery.

1938, Modern Age Books, Inc., New York, New York. Books.

1935, Lawrence Paper Co., Lawrence, Kansas. Paper and Fiber Boxes.

1935, Reynolds Metals Co. Inc., New York, New York. Metallic Sheet Material—Namely, Foil.

1939, Artic Roofings, Inc., Edge Moor, Alaska. Composition Shingles and Roll Roofing.

1925, B. H. Hakstad & Co., Chicago, Illinois. Cod Liver Oil.

1929, The Federal Washboard Co., Tiffin, Ohio. Washboards.

1935, Red Bird Stamp Co. Inc., St. Louis, Missouri. Trading Stamps.

1920, L. G. Lane, Los Angeles, California. Insecticide.

1932, Patrick A. Powers, New York, New York. Silent and/or Sound or Talking Motion Picture Films.

1920, Martha Florence Butcher, Washington, D. C. Insecticides.

1931, McCarty Aniline & Extract Co. Inc., New York, New York. Preparation for Coating, Sizing, and Stiffening Rugs and To Prevent Their Slipping.

1936, Pennsylvania Rubber Co. Inc., Jeannette, Pennsylvania. Shuttlecocks.

1920, Joseph A. Murphy, Youngstown, Ohio. Hair-Tonics.

AMERICAN

1928, Milwaukee Grains & Feed Co., Milwaukee, Wisconsin. Horse and Dairy Feeds.

1927, American Seed and Food Products, Chicago, Illinois. Bird and Aquarium Supplies.

1925, Kenworthy Grain & Milling Co., Tacoma, Washington. Stock and Poultry Feed.

1927, Maurice L. Rothschild, Inc., Chicago, Illinois. Shoes Made of Leather.

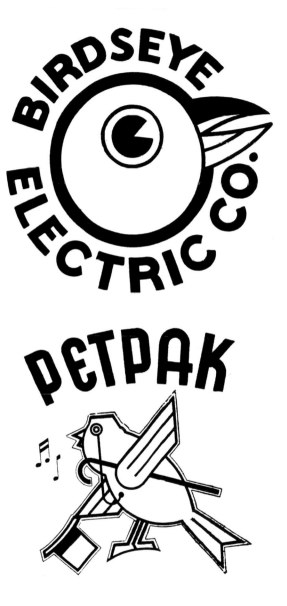

1920, International Sugar Feed Co., Minneapolis, Minnesota. Hog Feed.

1925, Jersee Co., Minneapolis, Minnesota. Egg Mash for Poultry.

1935, Birdseye Electric Co., Gloucester, Massachusetts. Electric Incandescent Lamps and Radio Vacuum Tubes, Packaged or Unpackaged.

1935, West's Products Co., Milwaukee, Wisconsin. Bird Seed.

FAIRCHILD

1920, Alligator Grip Co., Dallas, Texas. Tire Patches.

1931, A. Clavel & Fritz Lindenmeyer, Basel, Switzerland. Cotton, Cotton and Silk, Cotton and Wool, Silk and Artificial Silk.

1925, Fredriksstad Preserving Co., Fredriksstad, Norway. Canned Fish.

1929, Fairchild Aviation Corp., New York, New York. Internal-Combustion Engines.

Chicken IN THE ROUGH

PHIL-UP

Unicorn

FROG

1938, Beverly's and Beverly's Drive-In, Oklahoma City, Oklahoma. For Lunches Comprising Chicken, Potatoes, and Rolls.

1928, Francis H. Legget & Co., New York, New York. Breakfast Cocoa, Sweet Relish, Catsup, Olives, Sweet Mixed Pickles, Sour Mixed Pickles, Red-Currant Jelly, and Preserves.

1931, J. Hilborn & W. E. Reed, Inc., New York, New York. Sweaters Made of Woolen Yarn.

1938, Centerbar Co., Natick, Massachusetts. A Game Adapted To Be Played with Movable Pieces.

Cold Stream

THREE CARRIERS

Fair Chance

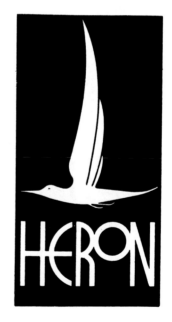

HERON

1932, The Great Atlantic & Pacific Tea Co., New York, New York. Canned Salmon.

1931, Mayflower Mills, Fort Wayne, Indiana. Wheat Flour, Phosphated Flour, and Self-Rising Flour.

1936, Harrington & Waring, New York, New York. Hosiery.

1936, Lydia V. Billing, Piedmont, California. Hair Grower.

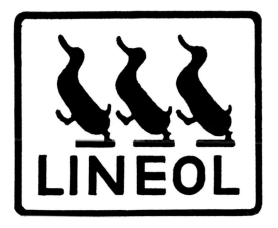

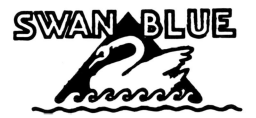

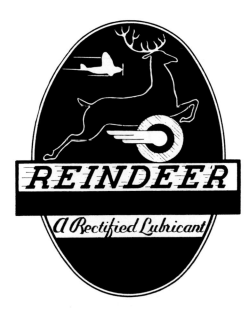

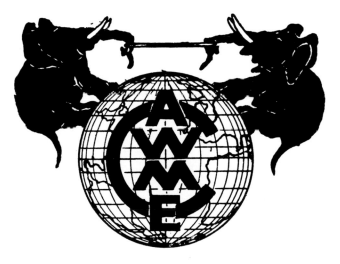

1928, Lineol Aktiengesellschaft, Brandenburg-on-the-Havel,
Germany. Toy Soldiers, Toy Animals, Toy Menageries, and Toy Farms.

1934, W. R. Arthur & Co. Inc., Chicago, Illinois. Lubricant oils.

1920, National Blue Corp., New York, New York. Laundry Blue.

1919, American Webbing Manufacturers Export Corp., New York,
New York. Elastic and Nonelastic Webbings.

TRANSPORTATION

Man has always had the urge to move. He possesses a childlike fascination with motion and flight that translates into the need to see, to travel, to expand.

Twentieth-century America harnessed the raw elements of motion, even lassoing the mysteries of flight, and in doing so captured the popular imagination.

With industrial designer Raymond Loewy came the modernization of travel and transport. Words like streamliner, luxury liner, and airship quickly became synonymous with speed, efficiency, dependability, and, as Lindbergh's flight illustrated, romance. America was on the move by ship, airplane, train, and truck. A piston with wings became a modern-day Pegasus.

Even the music of the era reflected the significance of transportation. What big band worth its chops didn't have a set of train songs to swing to, or one or two road movies under its belt?

Advertisers found that, for consumers, the image of the streamliner suggested that the coffee was fresh or the needles were sharp. Association with the Pullman locomotive implied that blades were tough, and there when you needed them. When Douglas Aircraft circled the earth, it was a graphic way of saying "you can get there from here." And America has continued to do just that, without ever looking back.

1935, Simplex Products Corporation, Cleveland, Ohio. Piston Rings.

1938, Gerson Goodman Tutelman Co., Philadelphia, Pennsylvania. Men's and Boys' Dress Shirts.

1936, Staten Island Home Utilities, Inc., Staten Island, New York. Gasoline.

1937, Julius J. Stern, Chicago, Illinois. Veneers, Plywood Boards and Panels, Technical Plywood, and Composition Boards.

1934, Kroll Engineering Associates, New York, New York. Apparatus for Elevating a Motor Vehicle Chassis.

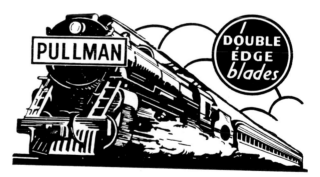

1937, McGaugh Hosiery Mills, Dallas, Texas. Hosiery, Neckties, and Handkerchiefs.

1938, Connell Bros. Co. Inc., San Francisco, California. Flour; Fresh Grapes, Apples, Pears, Plums, Oranges, and Lemons; and Canned Fish.

1937, Douglas Aircraft Co. Inc., Santa Monica, California. Airplanes and Structural Parts.

1938, Dave Pullman, Akron, Ohio. Razor Blades.

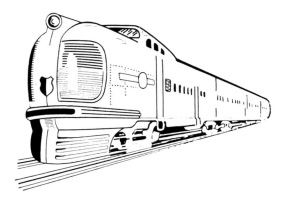

1938, Coffee Sales Co., Cedar Rapids, Iowa. Coffee.

1933, O'Hara Bros. Co. Inc., Boston, Massachusetts. Fresh Fish Fillets, Frozen Fish Fillets.

1935, North American Aviation, Inc., Dunford, Maryland. Airplanes.

1934, Lockheed Aircraft Corp. Burbank, California. Aeroplanes and Parts Therefor Not in Other Classes.

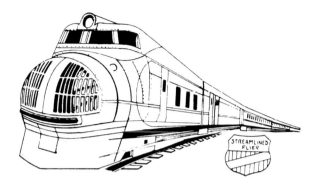

1935, Titan Co., A/S., Fredrikstad, Norway. Paint Pigments, Paste Paints, and Ready Mixed Paints.

1938, Stetson China Co. Inc., Chicago, Illinois. China Tableware.

1938, Strauss Bros. & Co., New York, New York. Needles for Hand Use.

1925, The Wilcox-Hayes Co., Portland, Oregon. Wheat Flour.

1920, **Griswold Seed & Nursery Co.,** Lincoln, Nebraska. Flower, Vegetable, and Field Seeds.

1931, **Frank H. Fleer Corp.,** Philadelphia, Pennsylvania. Chewing Gum Comprised of a Core of Chewing Gum and a Coating or Covering of Hard Candy.

1925, **Washburn Crosby Co.,** Minneapolis, Minnesota. Wheat Flour.

1937, **Houston Milling Co.,** Houston, Texas. Wheat Flour.

1934, **Stockton Oil Co.,** Stockton, California. Gasoline.

1932, **Wells-Lamont-Smith Corp.,** Minneapolis, Minnesota. Work Gloves of Fabric and Combined Fabric Leather.

1928, **Sinclair Refining Co.,** New York, New York. Gasoline.

1928, **George R. Burrows, Inc.,** New York, New York. Tarpaulins, Particularly Tarpaulins Suitable for Use as Coverings for All Manner of Boats, Trucks, or Merchandise.

SKY-FLIER

AUTO TRUCK
EQUIPMENT CO.
PITTSBURGH PENNA

AUTO

AK·RO·NO

1931, Osborn Paper Co., Marion, Indiana. Writing Tablets and Pencil Tablets.

1923, Auto Truck Equipment Co. Pittsburgh, Pennsylania. Cabs, Trucks, Vans, Wood and Metal Bodies, Special Bodies, Wood Bodies, Stakes, Covers, and Sideboards.

1928, Have a Heart Candy Co., Portland, Oregon. Candy Bars.

1938, The Ak-Ro-No Auto Products Co., Vandalia, Illinois. Preparation for Cleaning and Restoring Lustre to Rubber Products.

1929, Gager Lime Manufacturing Co., Sherwood and Chattanooga, Tennessee. Slaked Lime in Powdered Form.

1936, Safety Steering Stabilizer Co., Pittsburgh, Pennsylvania. Automobile Steering Stabilizers.

1924, The Hi-Flier Manufacturing Co., Decatur, Illinois. Kites.

1932, Alpine Ice Cream Co. Inc., Long Island, New York. Ice Cream.

DORNIER

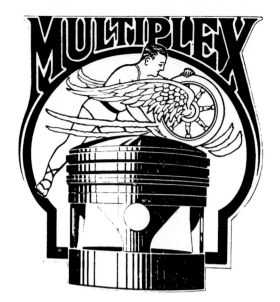

1936, Dornier-Metallbauten G. m. b. H.,
Friedrichshafen-on-the-Bodensee, Germany. Aeroplanes and
Structural Parts of Aeroplanes.

1931, Chicago Roller Skate Co., Chicago, Illinois. Roller Skates.

1924, Multiplex Manufacturing Co., Berwick, Pennsylvania. Pistons
for Engines.

1938, Armand Weill & Co., Territory of Hawaii. Men's and Boys'
Dress, Negligee, Hosiery, Pajamas, and Leather Fabrics.

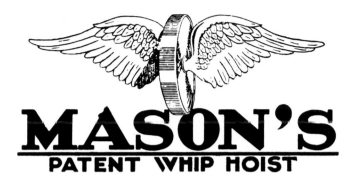

1920, Volney W. Mason & Co. Inc., Providence, Rhode Island. Hoisting Machinery.

1938, Estee Bedding Co., Chicago, Illinois. Mattresses, Studio Couches, and Bed Springs.

1928, Tuf Nut Garment Mfg. Co., Little Rock, Arkansas. Men's and Boys' Negligee Shirts, Trousers, and Coats.

1931, Chicago Roller Skate Co. Chicago, Illinois. Roller Skates.

CIRCLES & SHAPES

The circle as a design element lures us into its framework. It forces our eyes to surround the image within, heightening the sense of internal movement and producing, in some cases, a three-dimensional effect.

By dividing the area within a square, diamond, or triangle into sections, the designer creates an optical illusion. The segmentation simulates a pattern of dynamic directional relationships. By contrast, Milton Bradley's mark for checkerboards is just as it reads— "E. Z. on the eyes."

Equally notable among these designs is the manipulation of type, which adds to the overall form of the mark. Some of the shapes are rounded, intensifying the suggestion of motion. Others, like Eternit Emaille's ominous E. E., are dramatically linear.

The aura of modernity is pervasive in these trademarks, which marry vaguely familiar forms to a new energetic vision in ways that somehow remain comfortable to the eye.

A motif that seems to stand out here is the sphere of life itself, the earth. We find it speared, spiked, claimed, conquered, and painted. This symbolic globe implies the manufacturer's offer of the world on a string, dangling a tantalizing choice before consumers: life as they would most like to have it themselves.

1938, J. E. Harton Co., San Francisco, California. Twine Dispensers.

1936, Royal Revues, Inc., Hollywood, California. Sensitized Film Suitable for Use in Making Motion Pictures.

1925, Radio Gasoline Co., Los Angeles, California. Petroleum Products.

1938, Container Corp. of America, Chicago, Illinois. Wood Pulp.

1925, Texas Portland Cement Co., Dallas, Texas. Portland Cement.

1937, Funk Bros. Seed Co. Inc., Chicago, Illinois. Seeds, Seed Grains.

1938, Victor L. S. Hafner, New York, New York. Sensitized Motion Picture Film.

1937, Natural Set Up Sales Corp., St. Louis, Missouri. Carbonated Soft Drinks with Lemon Flavor Predominating.

1925, Northern Pacific Railway Co., St. Paul, Minnesota. Booklets, Circulars, and Pamphlets.

1936, Gould Storage Battery Corp., St. Paul, Minnesota. Storage Batteries.

1925, Barrows Optical Corp., Providence, Rhode Island. Ophthalmic Mountings.

1936, Cornelius Publications, Inc., Indianapolis, Indiana. Periodical Published at Regular Intervals.

1938, Sigmund W. Zabienek, Chelsea, Massachusetts. Game of a Miniature Hockey Rink.

1925, Mackie Pine Oil Specialty Co. Inc., Covington, Louisiana. Disinfectant and Deodorant Used in the Bath.

1938, Rex Electric Co., New York, New York. Photographic Apparatus.

1925, Walter M. Steppacher & Bro. Inc., Philadelphia, Pennsylvania. Dress, Negligee, Night, or Work Shirts, Pajamas, and Men's Textile Underwear.

1938, R. M. Hollingshead Corp., Camden, New Jersey. Varnish, Stains, Fillers, Lacquers, Ready Mixed Paints, Enamels, and Coatings.

1925, Walter M. Steppacher & Bro. Inc., Philadelphia, Pennsylvania. Dress, Negligee, Night, or Work Shirts, Pajamas, and Men's Textile Underwear.

1936, Republic Electric Manufacturing Co., Davenport, Iowa. Radio Receiving Sets, Generators, and Storage Batteries.

1935, The Sherwin-Williams Co., Cleveland, Ohio. Silicate, Purified Clay, China Clay, and Enamel Frit.

1929, Milton Bradley Co., Springfield, Massachusetts. Checkerboards.

1935, Powers New Products Corp., Wilmington, Delaware and
New York, New York. Toy Tracing Sets.

1936, Mayer-Stern, Inc., Allentown, Indiana. Men's and Women's
Polo and Sport Shirts.

1926, J. E. Rhoads & Sons, Philadelphia, Pennsylvania. Belt
Preserver and Dressing and Liquid Belt Preserver.

1936, Atlas Tack Corp., Fairhaven, Massachusetts. Nails and Tacks.

HOME RUN

BOWL-LO

JOY-BLUE

"Justa Farm"

1920, The Acme Mills, Hopkinsville, Kentucky. Self-Rising Wheat Flour.

1920, National Blue Corp., New York, New York. Laundry Blue.

1932, Bowl-Lo Chemical Co., Canton, Ohio. Preparation for Cleaning Toilet Bowls.

1935, Stanley P. Brown, Mission, Texas. Fresh Citrus Fruits.

1928, Economy Shoe Heel Corp., New York, New York. Shoe Heels.

1929, Heywood Boot & Shoe Co., Worcester, Massachusetts. For Leather Boots and Shoes.

1935, Hy-Kare Laboratories, Chicago, Illinois. Manipulator (Toothbrushes).

1938, Master Chemical Co., Portland, Oregon. Bleacher, Cleaner, Deodorizer, and Disinfectants.

1931, The Tabulating Machine Co., New York, New York. For Card Controlled Tabulating Machines, Card Punching Machines, Card Sorting Machines, and Card Duplicating Machines.

1935, H. L. Nelke, Philadelphia, Pennsylvania. Stocking Protectors for the Toes of Stockings.

1935, The Liquid Carbonic Corp., Chicago, Illinois. Solid Carbon Dioxide.

1925, Colonial Steel Co., Pittsburgh, Pennsylvania. Electric Steel Plates.

1920, Johnson Oil Refining Co., Chicago Heights, Illinois. Petroleum, Gasoline, Kerosene, Naphtha, Lubricating Oils, Distillate, and Lubricating Greases.

1937, The Enns Milling Co., Inman, Kansas. Wheat Flour and Self-Rising Wheat Flour.

1938, Dexter Woolen Corp., New York, New York. Wool Piece Goods.

1937, Barkon-Frink Tube Lighting Corp., Long Island City, New York. For Electric Carbon Dioxide Lamps of High and Low Voltage.

1927, Household Guide Corp., New York, New York. Publication Issued Monthly.

1934, Delta Electric Co., Marion, Indiana. Electric Hand Lanterns, Electric Bicycle Lamps, Electric Vehicle Lamps, and Electric Horns.

1938, Olden Minerals, Inc., Los Angeles, California. Pharmaceutical Preparations Used in Mineral Baths for Inducing Sleep, Promoting Circulation of the Blood, Reducing Weight, and Alleviating Pains.

1920, Earle Gernert, Billings, Montana. Canned Vegetables.

1929, Sklaroff Brothers, Philadelphia, Pennsylvania. Hosiery.

1928, Société Anonyme Eternit Emaille, Cappelle-au-Bois, Belgium. Building Materials—Namely, Plates, Tiles, Blocks, and Pipes of Enameled Asbestos Cement.

1938, The Collectaguide Co., New York, New York. Looseleaf Book Covers.

1936, National Sulphur Co. Inc., New York, New York. Flowers of Sulphur.

1932, Shell Oil Co., San Francisco, California. Gasoline and Lubricating Oils.

1928, H. C. Cole Milling Co., Chester, Illinois. Wheat Flour and Self-Rising Flour.

1920, Oppenheimer & Bertener, Inc., New York, New York. Printed and Woven Cotton Fabrics and Cotton Textiles of All Descriptions.

1932, A. H. Geuting Co., Philadelphia, Pennsylvania. Men's, Women's, and Children's Boots and Shoes. Made of Leather, Fabric, Rubber, or any Combination of One or More of Said Materials.

1932, Sandor Radanovits, Chicago, Illinois. Mustard.

1923, Jacob Dold Packing Co., New York, New York. Cuts of Meats, as Smoked, Boneless Butts.

1925, Skelly Oil Co., Tulsa, Oklahoma. Natural Gasoline, Motor Gasoline, Kerosene, Distillate, Gas Oil, and Industrial Lubricants.

1936, Rocky Mountain Garment Manufacturing Co., Denver, Colorado. Service Apparel—Namely, Wash Uniforms, Cooks' and Waitresses' Uniforms, Mechanics' Suits and Coats.

COWBOYS & INDIANS

I t seems that how the West was won was also how products were sold—or at least represented by Eastern and Midwestern manufacturers. These marks are packed with the spirit of America's rugged pioneers and her native people.

America's tough cowboy and stoic Indian stood as symbols of independence and of the ability to take available material and build a nation.

In the twenties and thirties, ours was a land of juxtaposition, of bustling cities with elevated trains, posh hotels, and glitzy night spots in the East, and of gin mills, cattle runs, mining camps, and Indian reservations in a largely wild and untamed West. In Texas, New Mexico, and Arizona, cowboys packed six-guns as they strolled in the muddy streets.

It was from this vast heartland that our myths were created and our heroes erected: Wild Bill Hickok, Tom Mix, the singing cowboys, and Sitting Bull, Geronimo, and Pocahontas the Indian princess.

These designs depict strength, durability, and ruggedness. They join images of the lone cowboy and the Indian chief with names like The Plainsman, Rough Rider, Bronco Kraft, and Rodeo to infuse the product with the qualities of American heroes.

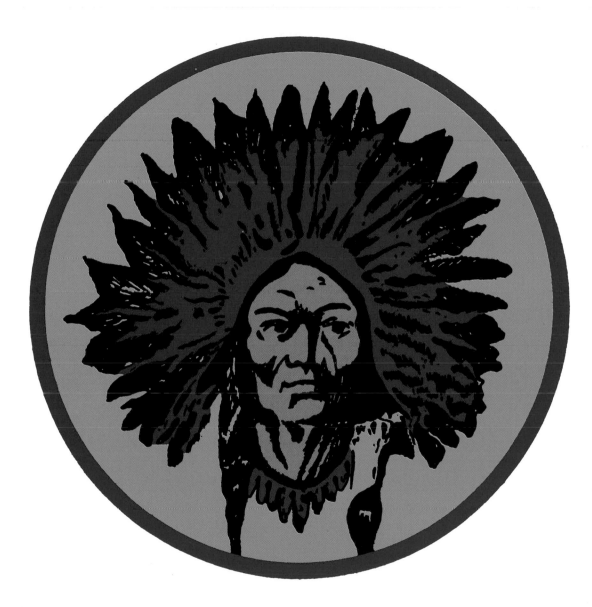

1923, Chief Manufacturing Company, Indianapolis, Indiana.
Machines for Scrubbing Carpets with Water or Other Suitable Cleaning
Agents.

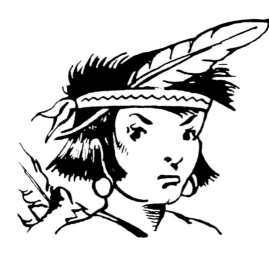

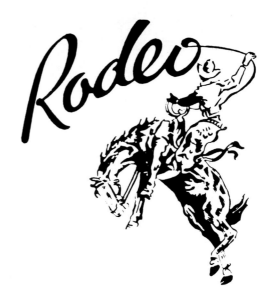

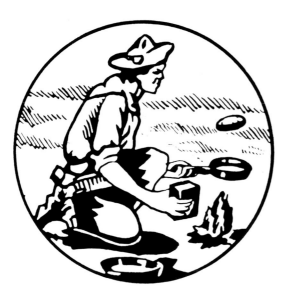

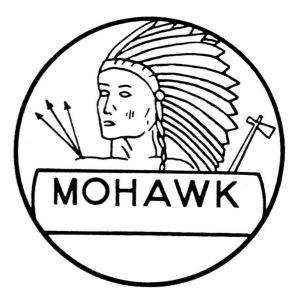

1939, Little Beaver, Inc., Cleveland, Ohio. Comic Drawings
Published in a Series in Daily and Sunday Newspapers.

1938, The Keefe Packing Co., Arkansas City, Kansas. Barbecue
Ham.

1937, Albers Bros. Milling Co., Portland, Oregon. Corn Flakes.

1938, Medbury & Carroll, Inc., New York, New York. Men's Hats.

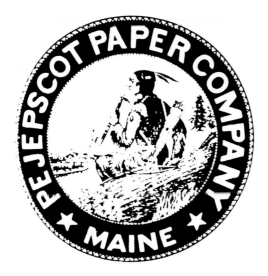

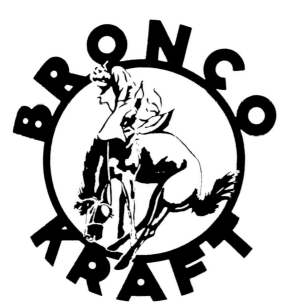

1937, Pejepscot Paper Co., Brunswick Maine. Newsprint Paper and Writing Paper.

1939, Cheaspeake Camp Corp., Franklin, Virginia. Kraft Paper.

1937, Wilson Brothers, Chicago, Illinois. Men's Neckties.

1938, North American Refractories Co., Cleveland, Ohio. Refractories.

BRAND

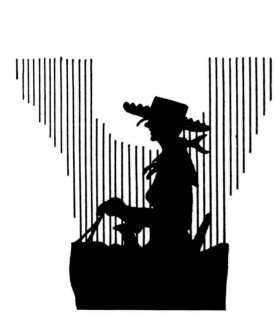

NOKOMIS

1930, Western Garment Mfg. Co., Wichita Falls, Texas. Boys' Pants, Boys' Shirts, and Boys' Play Suits.

1932, De Leon Peanut Co., De Leon, Texas. Shelled Peanuts.

1932, Sunbeam Products Co., Toledo, Ohio. Dyes, Dressings, Polishes, and Cleaners Used on Shoes.

1925, Minneapolis Milling Co., Minneapolis, Minnesota. Wheat Flour.

TRADE MARK

1920, Frederick F. Brinker, Peoria, Illinois. Canned Adhesive Rubber.

1934, American Grain Distillers, Inc., Detroit, Michigan. Whiskey, Brandy, Gin, Rum, and Alcoholic Cordials.

1934, Liberty Foundries Co., Rockford, Illinois. Automobile Heaters and Parts or Accessories Therefor, and More Particularly Heaters Heated by the Engine-Cooling Medium.

1927, The Stroh Products Co., Detroit, Michiagan. Malt Syrup.

SHAWMUT

WESTERN MADE
RODEO

SINCERE ET CONSTANTE · OSAGETEX

1932, **Foot Form Shoe Shops, Inc.,** New York, New York. Arch Supports, Foot Pads, and Cushions to be Used in Shoes.

1924, **Hicks-Hayward Co.,** El Paso, Texas. Pants, Coats, Breeches, Knickerbockers, and Negligee and Work Shirts.

1935, **Shawmut Products Co.,** New York, New York. Electric Storage Batteries.

1935, **Samuel Rochelson,** New York, New York. Dry Goods Consisting of Handkerchiefs, Bridge Sets, Towels, Luncheon Cloths, and Dresser and Buffet Scarfs.

1938, Indian Products Corp., Chicago, Illinois. Air-Conditioning Units.

1920, Pocahontas Braid Corp., New York, New York. Braid—Stitching, Elastic, Cord Edge, Cords, Lace, Seam-Binding, Fringe, Tassels, Rag-Tail Braid, and Pig-Tail Braid.

1935, Goldblatt Bros., Inc., Chicago, Illinois. Beer.

1920, A. O. Andersen & Co., San Francisco, California. Canned Fruits.

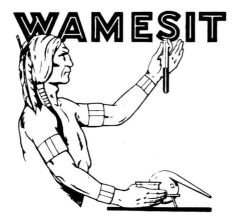

WAMESIT

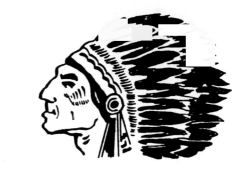

RAIN-CHIEF

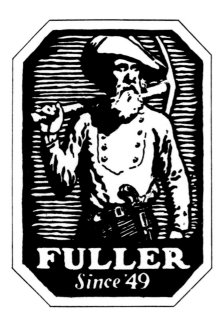

FULLER
Since '49

WESTERN CHIEF

1922, Wamesit Chemical Co., Lowell, Massachusetts. Dye Mordants, Such as Combinations of Ammonia and Lactic Acid, and Lactic Acid and Calcium Lactate.

1927, W. P. Fuller & Co., San Francisco, California. Sheet and Plate Glass, Wire Ribbed Glass, and Wire Corrugated Glass.

1938, Sleetex Co. Inc., New York, New York. Windshield Wiper.

1920, W. D. Allen Manufacturing Co., Chicago, Illinois. Stitched Canvas Belting.

1930, **Duart Permanent Wave Co.,** San Francisco, California. Electrical Hair Dryers.

1924, **The Approved Pictures Corp.,** New York. Motion Picture Films.

1920, **Hoyland Flour Mills Co.,** Kansas City, Missouri. Wheat Flour.

1931, **Peter G. Ten Eyck,** New Scotland, New York. Butter, Eggs, Fresh Milk, Cheese, Fresh Vegetables, and Fresh Deciduous Fruits.

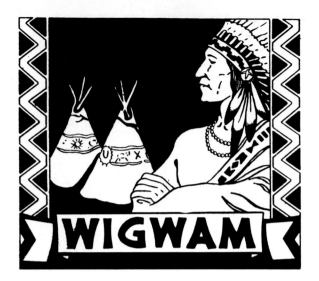

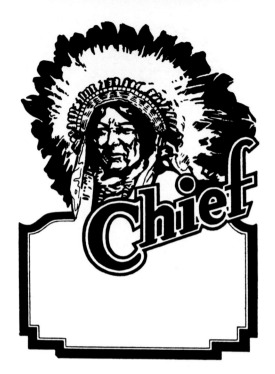

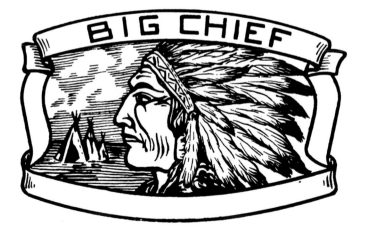

1934, Levy Bros. & Adler Rochester, Inc., Rochester, New York. Men's and Boys' Suits and Overcoats.

1925, New Jersey Brush Co., Bloomfield, New Jersey. Household Brushes. Used Specifically by Hand for Cleaning and Dusting Purposes.

1928, John Wood Mfg. Co., Los Angeles, California. Gas Water Heaters.

1935, Pittsburgh Dry Stencil Co., Pittsburgh, Pennsylvania. Duplicating Stencils and Correction Plates.

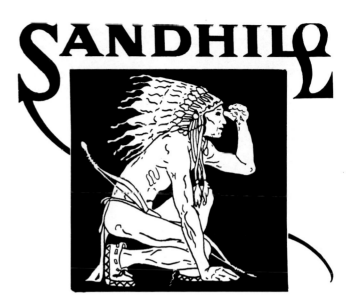

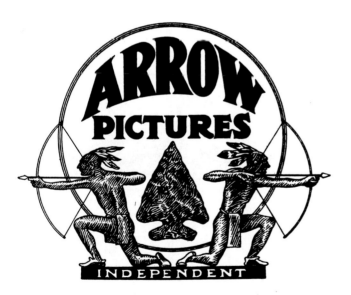

1932, Columbia Protektosite Co. Inc., Carlstadt, New Jersey. Sun Glasses, Snow Glasses, Leather Goggles, and Eye Protectors.

1922, Arrow Film Corp., New York, New York. Lithographs, Photographs, Advertising Cuts and Mats, and Press Books.

1923, Sandhill Fruit Growers Association, Aberdeen, North Carolina. Fruit—Namely, Peaches, and Apples.

1935, Tiona Petroleum Co., Philadelphia, Pennsylvania. Lubricating Oils, Particularly for Motors, Tractors, and Trucks.

1925, Pioneer Paper Co., Los Angeles, California. Composition Ready Prepared Roofings, Building Papers, Insulating Papers, Flashing Compound, Lap Cement, and Chip Board.

1936, Hecker-H-O Co., Inc., Buffalo, New York. Cereal Food Products—Namely, Toasted Wheat.

1925, Pioneer Cotton Mills, Guthrie, Oklahoma. Cotton Duck.

1939, The Sinclair Manufacturing Co., Toledo, Ohio. For Bleaching, Deodorizing, and Disinfecting Preparations.

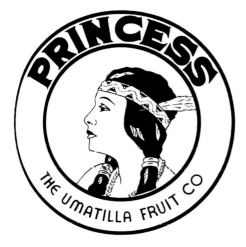

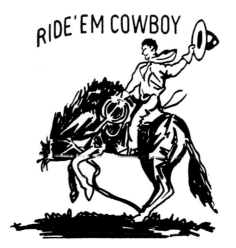

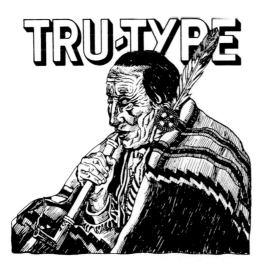

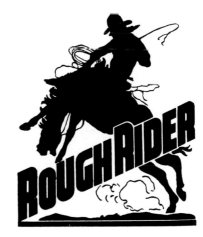

1938, The Umatilla Fruit Co., Umatilla, Oregon. Fresh Citrus Fruits.

1935, Winter Haven Fruit Sales Corp., Winter Haven, Florida. Fresh Citrus Fruits—Namely, Oranges, Grapefruits, and Tangerines.

1937, W. E. Anderson Co., Greenberg, Missouri. Potatoes in Their Natural State.

1937, John M. Wilson Feed Mills, Meridian, Mississippi. Horse and Mule Feed.

A logo is to a product what a signature is to a name—an emblazoned statement about its possessor. In early days the mark was a family coat of arms, a wax stamp and seal, or John Hancock's boastful flourish.

When America's jazz age hit, the motors ran a little faster. The streets buzzed and popped—Zingo, Zephyr, Zeen. Words played the distinct melody of the times. Products like Zip, Flash, and Glit had to live up to their names.

Some of the country's largest corporations gave themselves straightforward monikers, such as United States Steel, Container Corp. of America, and RCA.

Other companies chose to create images with their names, like Will-O-Weav's lasso, Ate-E-Ways, and The Fisheries Product's typography trout.

There is a certain elegance and motion to many of these marks, with the script faces denoting a mood or a focused energy. The akimbo type placement of Wazzoo creates a singsongy visual that corresponds directly to the product. The reverse is true for Rays, where the sleek Art Deco design deliberately says nothing about the treatment of piles.

1937, **King Kone Corporation,** New York, New York. Crackers.

1937, Zeen Chemical Co., Cleveland, Ohio. Dry Cleaning Fluid with Naphtha Base; Rug and Carpet Wet Shampoo, a Combination of Concentrated Dry Cleaner and Water.

1939, Grandpa Brands Co., Cincinnati, Ohio. Nonalcoholic Maltless Beverages Sold as Soft Drinks and for the Concentrates Thereof.

1936, Daubert and Knight, Columbus, Ohio. Medicinal Preparation in the Form of an Ointment and Adapted for Use in the Treatment of Piles, Hemorrhoids, and Rectal Disorders.

1938, Jingle Bell Ice Cream Co., Fort Worth, Texas. Ice Cream Bars.

1937, Household Utilities Corp., Chicago, Illinois. Clothes Dryer.

1937, Popular Brands, Inc., Wyncote, Pennsylvania. Detergent Preparation for Dish Washing.

1925, Grass-Grossinger Co., Scranton, Pennsylvania. Men's and Boys' Hats and Caps.

1935, The Coffield Protector Co., Dayton, Ohio. Lubricating Oil Compounds.

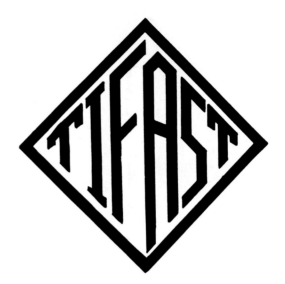

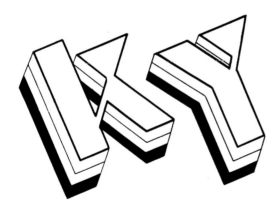

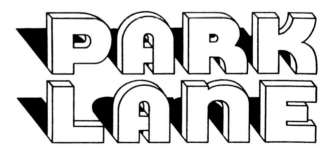

1932, Utility Manufacturing Co. Inc., New York, New York.
Photographic Cameras and Parts Thereof.

1926, H. P. Ulich & Co., New York, New York. Necktie Boxes and
Display Cards.

1929, Waco Coffee Co. Inc., Waco, Texas. Coffee.

1939, Fisher Bros. Paper Co. Inc., Fort Wayne, Indiana. Matches.

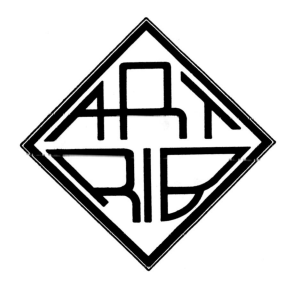

1938, Tremont Mills Corp., New York, New York. French Trimming Ribbon Sold by the Yard, Piece, or Bolt for Hats, Dresses, and Blouses.

1938, Harris Dunn Corp., New York, New York. Cigarette Cases and Humidors.

1938, Dominion Electrical Manufacturer Co., Mansfield, Ohio. Electric Fans.

1937, Paul Gibson, Richmond, Virginia. Automobile Cleaner Which Is a Solvent Cleaner for Removing Film and Dirt from the Finished Surface.

1935, Busy Bee Specialties Co., Chicago, Illinois. Candied Popcorn Confections.

1924, Jean Bergmann, New York, New York. Calculating Machines.

1938, The Sponge Rubber Ball Co., Derby, Connecticut. Play Sets Including Ball and Paddle.

1938, Morrison Engineering Co. Inc., Cleveland Ohio. Ovens.

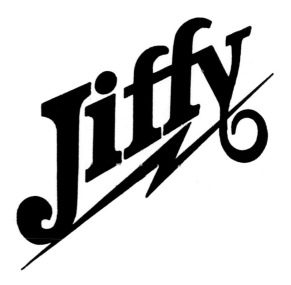

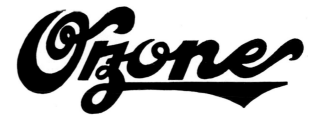

1938, Louis L. Jacob Inc., Orlando, Florida. Fresh Citrus Fruits.

1925, Edgar-Morgan Co., Memphis, Tennessee. Feeds and Foodstuffs for Poultry, Cattle, Horses, Mules, and Hogs.

1925, Jiffy Manufacturing Co., Huron, S. Dak. Liquid for Stopping Leaks in Radiators.

1937, Ozone Co. Inc., New Orleans, Louisiana. Spring Water and Nonalcoholic, Noncereal, Maltless Beverages, Sold as Soft Drinks and Syrups and Extracts for Making the Same.

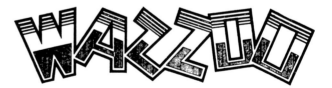

1938, Schaeffer Products Co., Cleveland, Ohio. Prophylactic Rubber Articles for the Prevention of Contagious Diseases.

1937, The Collins Co., Clinton, Iowa. Fly Swatters.

1936, The Darrow Co., Tulsa, Oklahoma. Varnish and Varnish Extender.

1936, The Waterbury Button Co., Waterbury, Connecticut. Novelty Humming Musical Instruments.

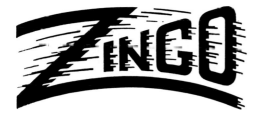

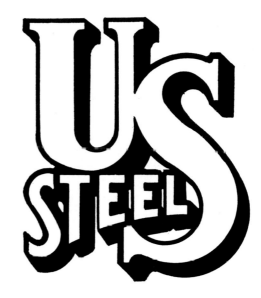

1934, Zingo Co., New York, New York. Toy Pistol.

1933, T. K. Cook, Cleveland, Ohio. Nonalcoholic, Maltless Beverages Sold as Soft Drinks and Syrups and Extracts for Making the Same.

1930, Universal Atlas Cement Co., Chicago, Illinois. Building Cement.

1938, Adam Hat Stores, Inc., New York, New York. Men's Hats.

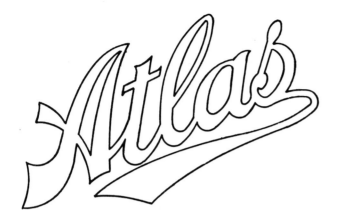

1929, Atlas Engineering Co., Clintonville, Wisconsin. Concrete Mixers, and Belt, Bucket, and Brick Conveyors.

1936, Ludwig Lustig, New York, New York. Diesel Engines, Gas Engines, and Other Internal-Combustion Engines and Parts Thereof.

1927, Elting Brothers, New York, New York. Men's and Women's Hosiery.

1935, Gladee Oil Co. Inc., Detroit, Michigan. Lubricating Oils and Greases and Gasoline.

1930, Marko Storage Battery Corp., Brooklyn, New York. Storage Batteries.

1927, Weickman Seat Co., New York, New York. Automobile Spring Seats.

1929, William G. Roe, Winter Haven, Florida. Fresh Citrus Fruits.

1920, Duncan Lumber Co., Portland, Oregon. Printed Trade Pamphlets, Circulars, Printed Matter in the Form of Books Containing Information Appertaining to the Lumber Business.

101

1937, Comic Favorites, Inc., Cleveland, Ohio. Magazine.

1934, G. & C. Merriam Co., Springfield, Massachusetts. Dictionaries.

1925, The George W. Luft Co. Inc., New York and Long Island City, New York. Day Creams, Night Creams, and Cleansing Creams.

1926, Red Sun Products Co., Chicago, Illinois. Malt Syrup for Food Purposes.

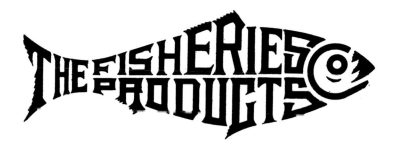

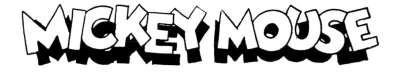

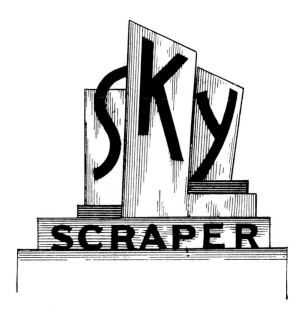

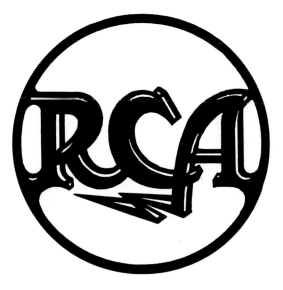

1921, Fisheries Products Co. Inc., New York, New York. Fertilizers.

1927, Frankl Galleries, New York, New York. Tables and Chairs for Household and Office Use, Bookcases, Cabinets, and Desks.

1928, Walter E. Disney, Hollywood, California. Motion Pictures Reproduced in Copies for Sale.

1928, Radio Corporation of America, New York, New York. For Broadcast Transmitters, Quartz Crystals, Condenser Microphones, Modulation Reactors, and Outside Pick-Up Equipment.

1932, Dewey Portland Cement Co., Kansas City, Missouri. Portland Cement.

1927, Tacoma Brewing Co., San Francisco, California. Cereal Malt Beverages Containing Less Than One-half of One Percent Alcohol.

1921, The American Paint Works, New Orleans, Louisiana. Dry, Paste, and Ready-Mixed Paints, House Paints, Interior and Exterior Finishes.

1938, Pohatcong Hosiery Mills, Inc., Washington, New Jersey. Ladies' Full Fashioned Silk Hosiery.

1937, Astatic Microphone Laboratory, Inc., Youngstown, Ohio. Crystal Microphones.

1935, Viennese Laboratories, Inc., Brooklyn, New York. For Rouge, Talcum, Body Powder, Toothpaste, Vanishing Cream, Polish, Shampoo, and Hair Tonic.

1938, Eata Bita Popcorn Co., Emporia, Kansas. French Fried Popcorn.

1934, American Record Corp., New York, New York. Phonograph Needles.

FERGUSON ORIGINATED STANDARD FACTORIES.

1930, Steel Publications Inc., Pittsburgh, Pennsylvania. Periodical.

1929, Whitemore Bros. Corp., Cambridge, Massachusetts. Ice Cream or Dressing.

1920, H. K. Ferguson Co., Cleveland, Ohio. Permanent Buildings and Structural Elements Thereof.

1924, General Oil Corp., Birmingham, Alabama. Motor Fuel Composed of a Blend of Benzol and Gasoline.

1931, **Southern Oak Flooring Industries,** Little Rock, Arkansas. Flooring—Namely, Tongued and Grooved, End-Matched, Square Edge Strips, Parquetry, and Fabricated Blocks.

1938, **General Mills, Inc.,** Minneapolis, Minnesota. Electrical Flashlights.

1929, **National Washboard Co.,** Chicago, Illinois. Washboards.

1929, **The Yantic Grain & Products Co.,** Norwich, Connecticut. Intermediate Chick Feed, Growing Feed, and Hog Feed.

1929, Permatite Manufacturing Co. Inc., Minneapolis, Minnesota. Electrical Crankcase Heaters.

1920, Consumers Brewing Co., Philadelphia, Pennsylvania. Cereal Beverages Made of Malt and Containing Less Than One-half of One Percent of Alcohol.

1936, Honey Packers, Inc., New York, New York. Honey.

1928, The Shelby Cycle Co., Shelby, Ohio. Bicycles.

1929, The Federal Washboard Co., Tiffin, Ohio. Washboards.

1921, The Grand Lake Co. Inc., New York, New York. Fiber Cord, Fiber Reed, and Fiber Stakes.

1938, Philomené G. Walsh, Chicago, Illinois. Sauce for Vegetables, Puddings, Soups, and Meats.

1938, Etsul Synthetic Products, Detroit, Michigan. Cleaning Solvent Compound for Use in General Household and Industrial Cleaning.

FACES & FIGURES

From Lucas's gap-toothed grin and the elegant Esquire Man, to a mosaic King Tut assembled from clips, gaskets, and pinions, we get a glimpse of how American designers in the twenties and thirties perceived public taste. We even get a peek at the public itself.

Many of the naive cartoonlike figures resemble someone you might know down the street, the happy family next door, or maybe your little brother. These are calculated attempts at associating you, the buyer, with particular products.

Behind the endearing little girl hugging her Papa's artificial leg are the grimmer realities of America after the Great War, and one company's way of softening them.

Prevalent, too, is a blatant racism that cut more deeply into the society of the twenties and thirties than these almost silly caricatures would have one believe. Today these logos would never see the top of an art director's desk.

Many marks look to the future, with angular robots and hi-tech imagery like RCA's eerie receiving-set skull. They also pay homage to the past, borrowing the speed of Mercury and the strength of a Trojan warrior.

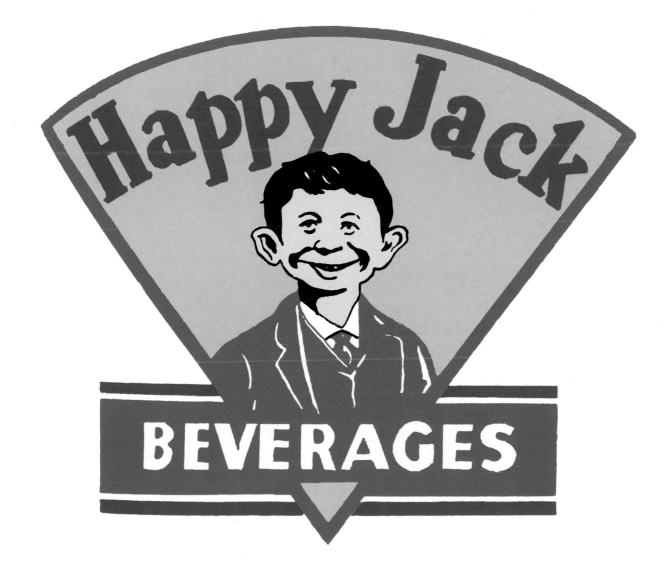

1939, A. B. Cook, Los Angeles, California. Nonalcoholic Beverages.

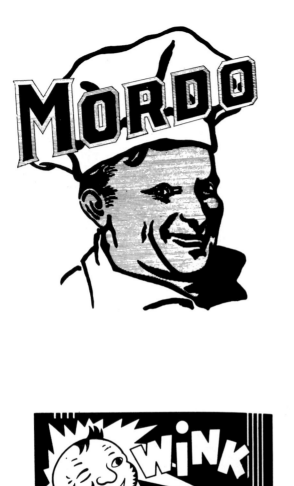

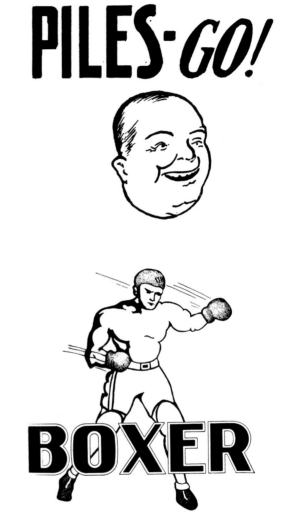

1938, **Waterside Milling Company,** Fostoria, Ohio. Wheat Flour.

1937, **W. K. Pile Remedy Co.,** Mount Vernon, Ohio. Medicine To Be Taken Internally for the Treatment of Piles.

1934, **Club Razor and Blade Mfg. Corp.,** Newark, New Jersey. Razor Blades.

1925, **Bay State Milling Co.,** Helena, Minnesota. Wheat Flour.

112

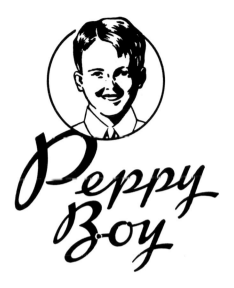

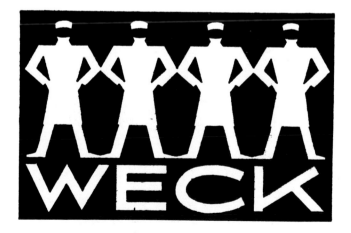

1934, Peppy Boy Noodle Co., Ellwood City, Pennsylvania. Noodles.

1936, Dolly Dimple Laboratories, Atlanta, Georgia. Hair Pomade.

1935, Esquire, Inc., Chicago, Illinois. Publication Issued Monthly and for a Column in a Newspaper Issued Weekly.

1930, Edward Weck & Son, Inc., New York, New York. Surgical Cutting Instruments, Forceps, Clamps, Clips, Needle Holders, Syringes, Surgeons' Rubber Gloves.

MARK OF
TESTED QUALITY

PEPS YOUR STEP
Drink SOL-KO
EACH GLASS CONTAINS 100 UNITS VITAMIN "D" SUNSHINE

EATS EVERYTHING IN THE PIPE

CANNIBAL

1937, Doughnut Corporation of America, New York, New York. Prepared Flour for Bread, Waffles, Doughnuts, and Cake, for Doughnuts and for Cake.

1938, John Sunshine Chemical Co. Inc., Chicago, Illinois. Drainpipe Cleaner.

1938, Garner-Tarkenton, Wilson, North Carolina. Nonalcoholic Soda Fountain Beverage.

1938, Becker Pretzel Bakeries, Baltimore, Maryland. Pretzels, Potato Chips, and Cheese Flavor Corn.

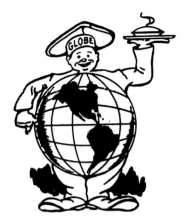

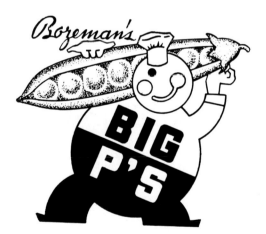

1925, New York Merchants Protective Co., New York, New York. Electrical Alarms and Signal Devices for Indicating Holdups, Burglaries, and the Like.

1925, Globe Dairy Lunch Co. Inc., Los Angeles, California. Ice Cream, Pies, Cakes, Doughnuts, Sandwiches, and Delicatessen Foods.

1937, Bozeman Canning Co., Mount Vernon, Washington. Canned Peas.

1938, The Axton-Fisher Tobacco Co., Louisville, Kentucky. Cigarettes.

1938, Masonite Corp., Chicago, Illinois. Paste Adhesives.

1938, Metalmen Inc., Detroit, Michigan. Automobile Body and Fender Metal Working Tools.

1932, Armor Products Inc., New York, New York. Mechanical Packings, Belting, Hose; Machinery Packing of All Kinds, in Particular, Flax, Jute, Asbestos, Duck, and Rubber.

1937, Combustion Engineering Co. Inc., New York, New York, and Chicago, Illinois. Pulverizing Apparatus.

1935, G. Krueger Brewing Co., Newark, New Jersey. Beer and Ale.

1936, Richmond Radiator Co. Inc., Uniontown, Pennsylvania. Bath Tubs, Lavatories, Sinks, and Laundry Trays.

1939, Basic Foods, Inc., Jersey City, New Jersey. Icing for Cakes and Cookies.

1937, Robinson Tag & Label Co., New York, New York. Gummed and Ungummed Labels.

1935, RCA Manufacturing Co. Inc., Camden, New Jersey. Radio
Receiving Sets, Television Receiving Sets, Kits for Radio Receiving Sets,
and Kits for Television Receiving Sets.

1929, Orange-Crush Co., Chicago, Illinois. Soft Drinks and Syrups.

1934, Youngs Rubber Corp., Inc., New York, New York.
Prophylactic Rubber Articles for the Prevention of Contagious
Diseases.

1935, Will Ross, Inc., Milwaukee, Wisconsin. Surgical Rubber
Goods, Surgical Glassware, Surgical Enamelware, Hypodermic
Syringes, and Hypodermic Needles.

1936, Dairymen's League Co-Operative Association, Inc., Utica and New York, New York. Milk, Powdered, Dried Skim Milk.

1937, Philadelphia Quartz Co., Philadelphia, Pennsylvania. Silicate of Soda, Either Anhydrous, Hydrated, or in Solution.

1936, James N. Walsh, New York, New York. Soles and Heels for Shoes.

1936, John Henry Miller, New York, New York. Preparation for the Treatment of the Throat.

ARAB COKE

1936, Mullins Manufacturing Corp., Salem, Ohio. Trailers.

1935, American Murex Corp., New York, New York. Welding Electrodes.

1935, The Forest City Rubber Co., Cleveland, Ohio. Antiseptic Solution, a Preparation for the Treatment of Burns, Sores, Cuts, and the Like.

1935, Union Coal Co. Inc., Rochester, New York. Coke, a Form of Coal.

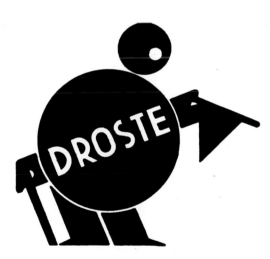

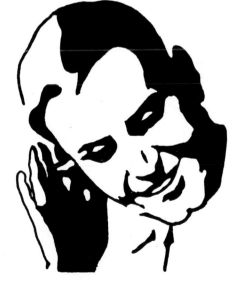

1925, Ansco Photoproducts, Inc., Binghamton, New York.
Sensitized Photographic Materials, Particularly Film.

1932, The Forging and Casting Corp., Ferndale, Michigan. Alloy
Steel Castings, Smooth Hammered Forgings, and Electrically Welded
Composite.

**1936, Naamlooze Vennootschap Droste's Cacao-en
Chocoladefabrieken,** Haarlem, Netherlands. Cocoa, Chocolate, and
Chocolates and Candies.

1928, Silent Automatic Corp., Detroit, Michigan. Liquid Fuel.

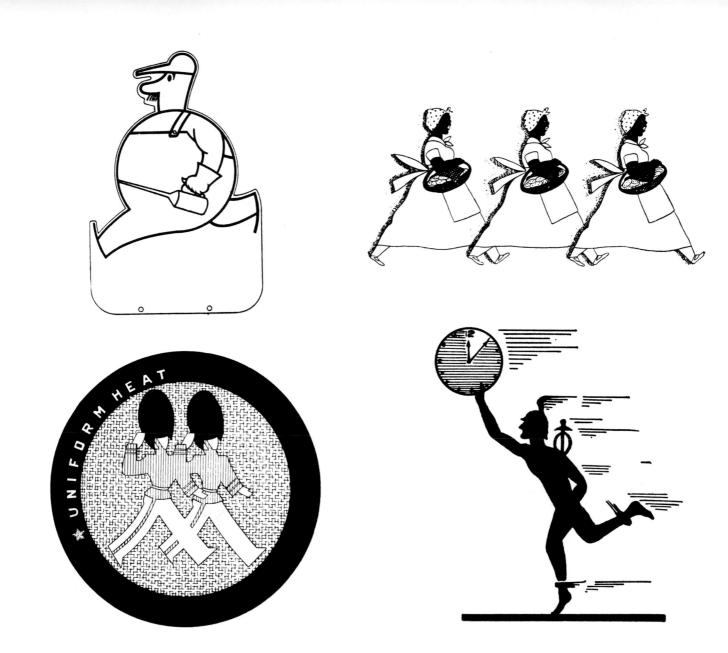

1936, Tide Water Oil Co., New York, New York. Gasoline, Lubricating Oils, and Greases.

1934, The Heil Co., Milwaukee, Wisconsin. Oil-Burning Heating Boilers and Furnaces for Building Heating Purposes and Oil Burners.

1937, Jacobs Candy Co. Inc., New Orleans, Louisiana. Candy.

1930, The Five Minute Home Cleaner Co., Chicago, Illinois. Dry Cleaner.

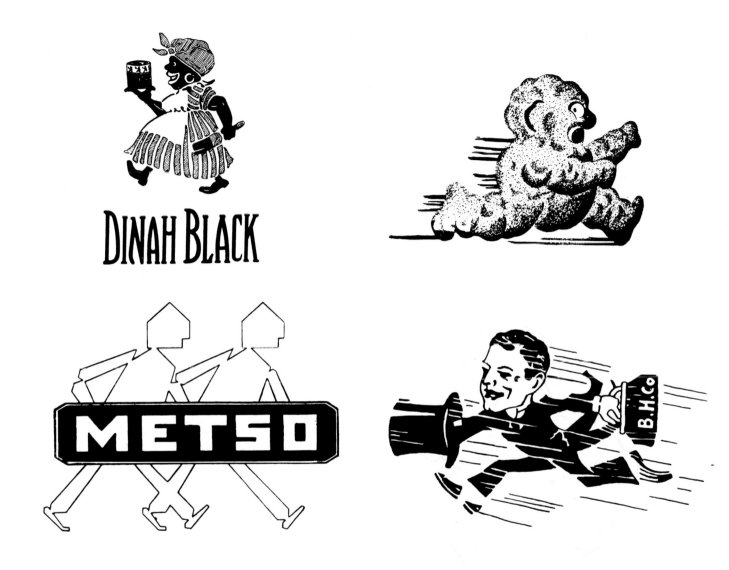

DINAH BLACK

METSO

1920, Boston Varnish Co., Everett, Massachusetts. Enamel for Coating Wood or Metal.

1930, Philadelphia Quartz Co., Philadelphia, Pennsylvania. Silicate of Soda Either Alone or in Admixture with Other Alkaline Salts.

1935, The Lubri-Zol Corp., Wickliffe, Ohio. Hydrocarbon Fuels Such as Gasoline and Chemically Treated Lubricating Compositions Such as Lubricating Oil and Grease.

1931, Charles L. Haber, New York, New York. Locks and Keys.

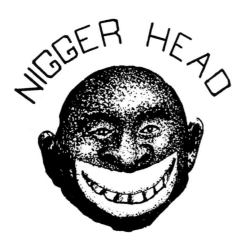

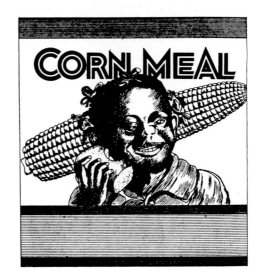

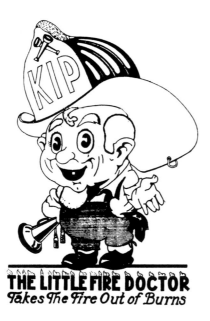

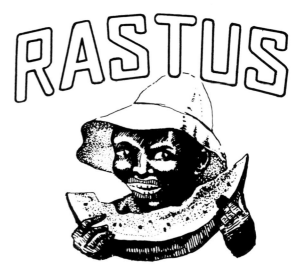

1920, George W. Graham, New York, New York. Stove Polish.

1927, The Kip Corp., Los Angeles, California. Salves or Preparations for the Relief of Skin and Body Burns.

1928, The Jenny Wren Co., Lawrence, Kansas. Corn Meal for Cooking.

1928, Kramer & Barcus, Leesburg, Florida. Fresh Watermelons.

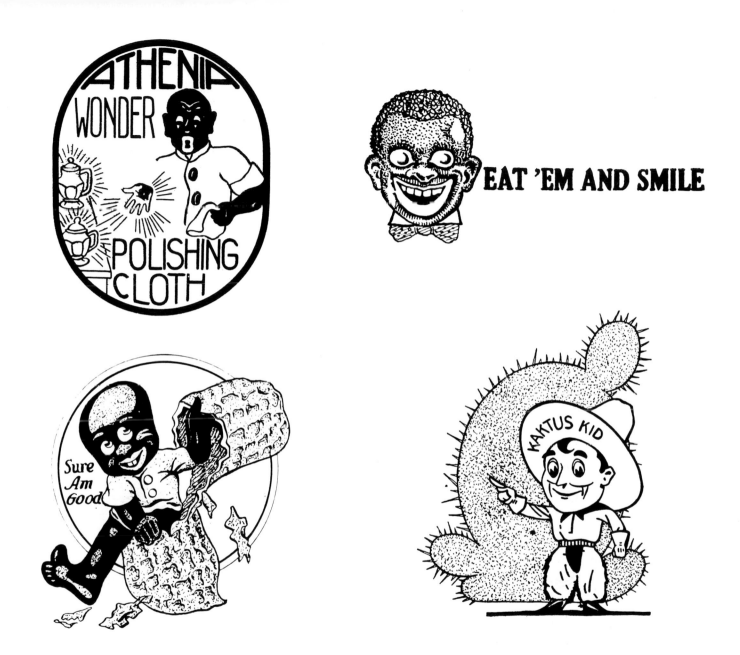

EAT 'EM AND SMILE

1923, Henry E. Howind, Co., Chicago, Illinois. Treated Cloths for Polishing and Cleaning Metal.

1925, Illinois Nut Products Co., Chicago, Illinois. Peanut Brittle and Candy-Covered Nuts.

1928, Ward-Owsley Co. Inc., Aberdeen, South Dakota. Candy.

1926, Cactus Mfg. Co., Los Angeles, California. Tire Patches and Tire Boots Made of Rubber and Fabric.

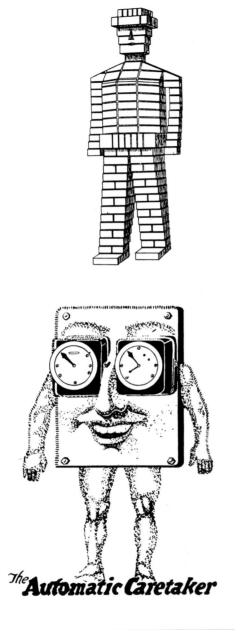

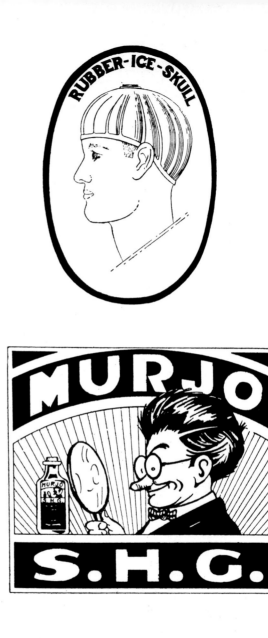

The **Automatic Caretaker**

1925, The Salt Lake Pressed Brick Co., Salt Lake City, Utah. Brick of All Kinds Employed in Building and Such Like Purposes.

1920, Consolidated Utilities Corp., Chicago, Illinois. Electric Light and Power Plants of a Portable Type.

1936, Edward Pomeranz, San Clemente, California. Containers for Frozen Liquid (Similar to Portrait) To Be Used on the Head.

1921, The Scalp Germicide Co., Youngstown, Ohio. A Germicidal Preparation Which Kills the Germs That Destroy the Hair, Promotes a Full Growth of Hair.

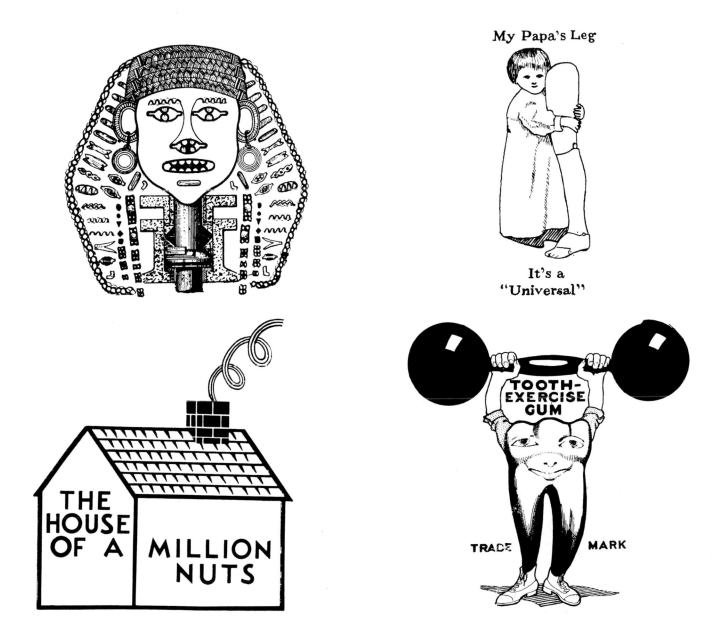

My Papa's Leg

It's a "Universal"

THE HOUSE OF A MILLION NUTS

TOOTH-EXERCISE GUM

TRADE MARK

1921, Goetze Gasket & Packing Co., New Brunswick, New Jersey. Asbestos Composition Packings.

1938, Awful Fresh MacFarlane, Berkeley, California. Salted Nuts, Candy, and Chocolate Coated Nuts.

1927, Universal Artificial Limb & Supply Co. Inc., Washington, D.C. Artificial Limbs.

1920, Don M. Dickinson, Jr., Detroit, Michigan. Chewing Gum.

Little Joe

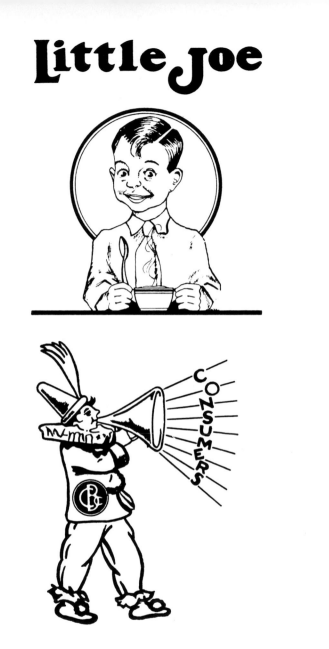

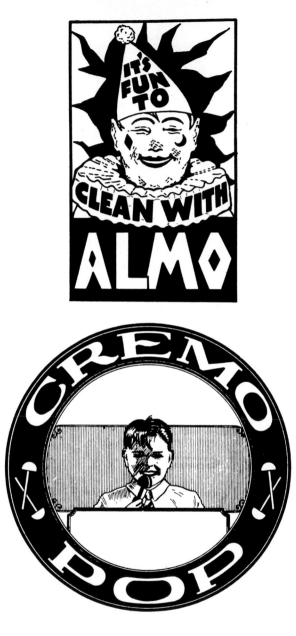

1930, **Northern Illinois Cereal Co.,** Lockport, Illinois. Grits.

1927, **Consumers Biscuit Co.,** New Orleans, Louisiana. Biscuits, Candy, and Ice Cream Cones.

1936, **Herman Weiss,** Yonkers, New York. Water Softener in Powder and Liquid and Compressed Cake Form.

1928, **Cremo Pop Corp.,** New York, New York. Chocolate Coating for Ice Cream.

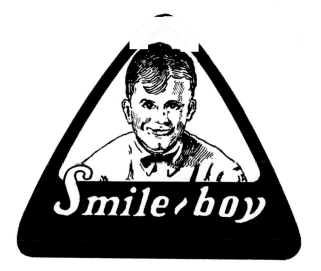

1923, Neuss, Hesslein & Co. Inc., New York, New York. Cotton Piece Goods, Bleached and Gray Cotton Piece Goods.

1931, The Lucas Manufacturing Co., Toledo, Ohio. Vehicle Heaters and Parts Thereof, Said Heaters Utilizing Hot Fluids from the Engine.

1930, Evansville Packing Co., Evansville, Indiana. Prepared, Smoked, and Dried Beef.

1939, Alfred Rosenburg, Asbury Park, New Jersey. Theatrical Costumes.

1928, Spartan Aircraft Co., Tulsa, Oklahoma. Airplanes and
Airplane Structural Parts.

1937, Gerts Lumbard and Co., Chicago, Illinois. Paint Brushes.

1936, Red Arrow Products Co., Philadelphia, Pennsylvania. Spark
Plugs.

1939, American Fixture and Mfg. Co., St. Louis, Missouri.
Furniture—Namely, Chairs, Tables, Stools, and Racks.

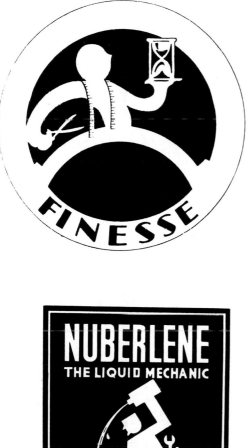

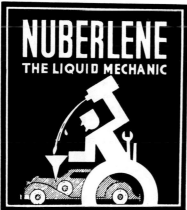

1935, Hahlo & Solomon Inc., New York, New York. Men's and Women's Clothing.

1934, Nuberlene Liquid Mechanic, Inc., San Antonio, Texas. Lubricant to Be Mixed with the Crankcase Oil of Internal-Combustion Engines.

1935, Petra Manufacturing Co., Chicago, Illinois. Permanent Hair Waving Pads or Sachets.

1934, United Necessities Corp., Bartlesville, Oklahoma. Cleaning and Polishing Preparation for Glassware, Windshields, Silver, Chromium, Porcelain, and Other Hard Surfaces.